D0425895

THOMAS KINKADE

Let
FREEDOM
Ring

Let FREEDOM *Ring*

Thomas Kinkade

**Andrews McMeel
Publishing**

Kansas City

ISBN: 0-7407-2706-0

Library of Congress Control Number: 2002111559

03 04 05 06 07 TWP 10 9 8 7 6 5 4 3 2 1

Compiled by Patrick Regan

I believe in the transforming power of light. And I believe that freedom casts a light all its own.

*F*ormer U.S. president Ronald Reagan once imagined our nation as a "shining city on a hill for all mankind to see." I've always loved that imagery, and I think it can be extended even further. I believe that every individual also has the power— and even the duty—to shine for his nation, and the world, to see. We cast our light in many ways: by living in accordance with our faith, by loving and sacrificing for

our families, by nurturing our own gifts and those of others, and by having the courage to stand up for what we believe in.

*P*assionate words about our country—its land, its laws, its ideals, and its people—also have the power to illuminate, to transform, and to inspire. This book presents some of my favorite words about this country which God has so richly blessed.

LONG MAY THE LIGHT OF FREEDOM SHINE.

THOMAS KINKADE

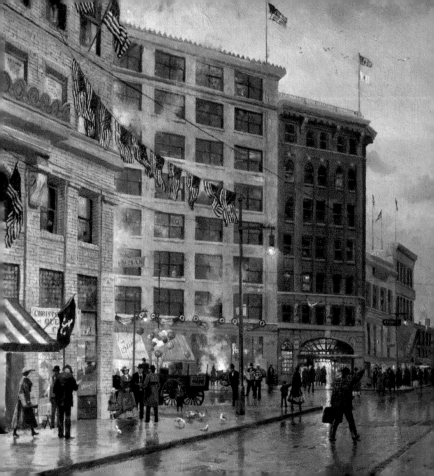

A

thoughtful mind,

when it sees

a nation's flag,

sees not the flag

only, but the

nation itself.

HENRY WARD BEECHER

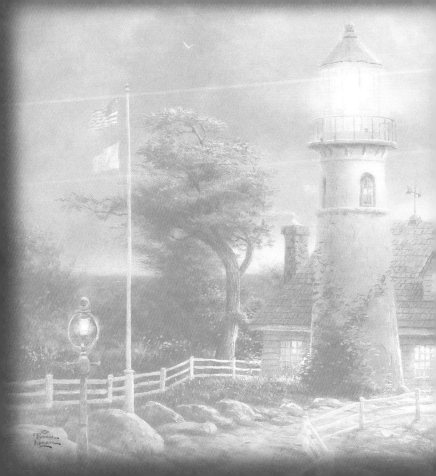

AMERICA

is a tune. It must be sung together.

GERALD STANLEY LEE

*E*ach life has the ability to touch other lives, which in turn touch yet more lives. And so, person by person, generation by generation, a world and a future are shaped.

THOMAS KINKADE

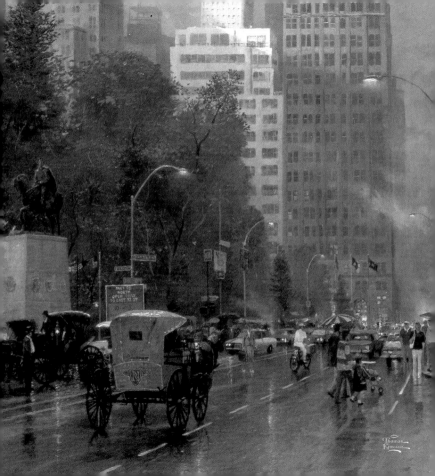

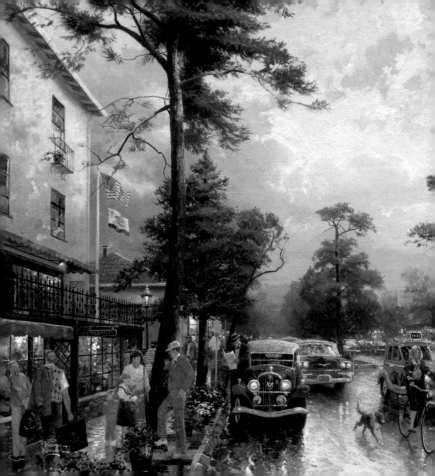

*L*et music
swell the breeze,

And ring from
all the trees

Sweet Freedom's
song.

From the song "America" by
SAMUEL F. SMITH

LIBERTY,
when it begins to take root,
is a plant of rapid growth.

GEORGE WASHINGTON

THE CAUSE OF
FREEDOM
IS THE CAUSE OF
GOD.

SAMUEL BOWLES

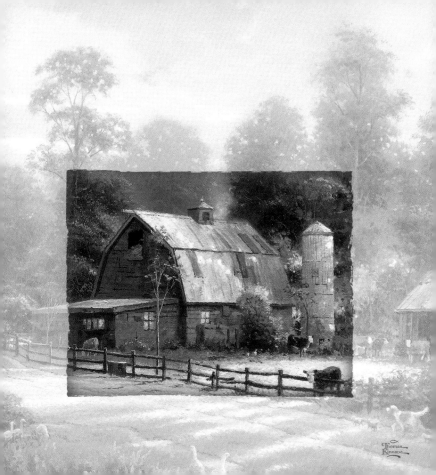

\mathcal{W}e hold
these truths to be
self-evident, that all men
are created equal,
that they are endowed by
their Creator with certain
unalienable Rights,
that among these are
Life, Liberty and
the pursuit of Happiness.

DECLARATION OF INDEPENDENCE

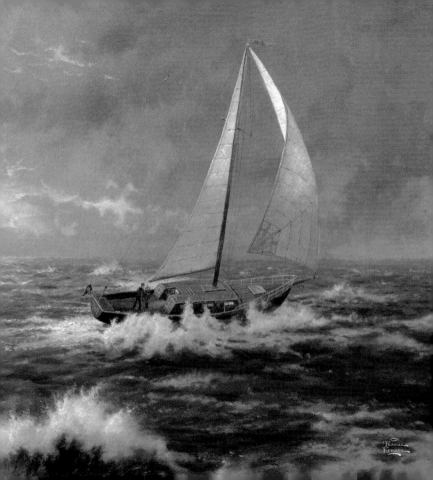

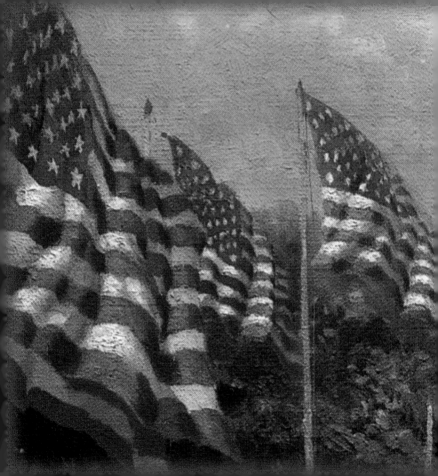

One FLAG,
one LAND,
one HEART,
one HAND,
one NATION,
EVERMORE!

OLIVER WENDELL HOLMES

Υet, Freedom!
yet thy banner,
torn, but flying,
streams like the
thunderstorm
against the wind.

LORD BYRON

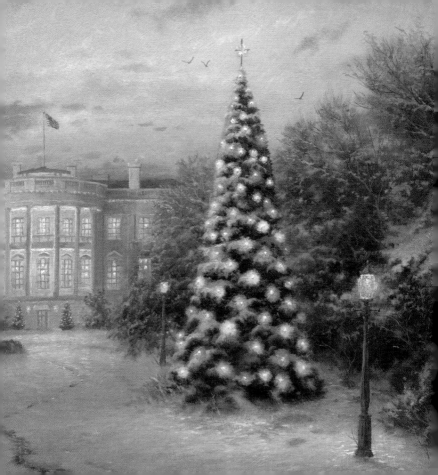

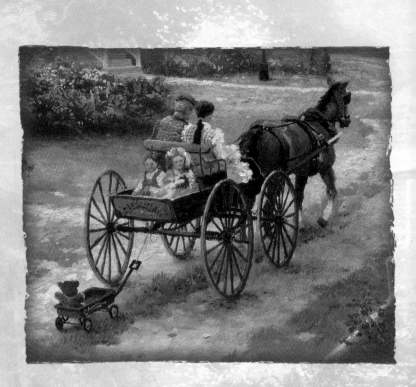

THE GREATEST GLORY

OF A FREE-BORN PEOPLE

IS TO TRANSMIT

THAT FREEDOM TO

THEIR CHILDREN.

WILLIAM HAVARD

*O*ur institutions of freedom will not survive unless they are constantly replenished by the faith that gave them birth.

JOHN FOSTER DULLES

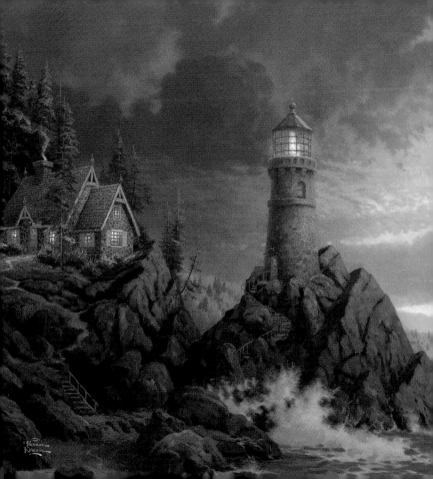
Thomas
Kinkade

*G*od grants
LIBERTY only
to those who
love it, and are
always ready to
GUARD and
DEFEND it.

DANIEL WEBSTER

I like to see
a man proud of
the place in which
he lives. I like to
see a man who
lives in it so that
his place will be
proud of him.

ABRAHAM LINCOLN

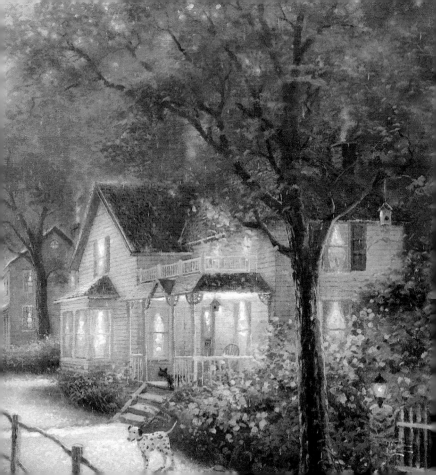

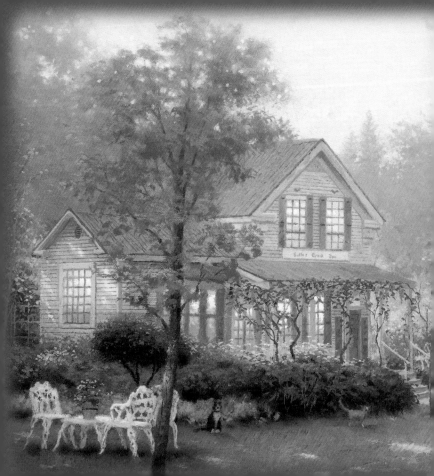

O beautiful
for heroes proved

In liberating strife,

Who more than self
their country loved

And mercy more
than life!

From the song "AMERICA THE BEAUTIFUL"
by KATHARINE LEE BATES

LIBERTY
WITHOUT
LEARNING

IS ALWAYS IN PERIL AND

LEARNING WITHOUT LIBERTY

IS ALWAYS IN VAIN.

JOHN F. KENNEDY

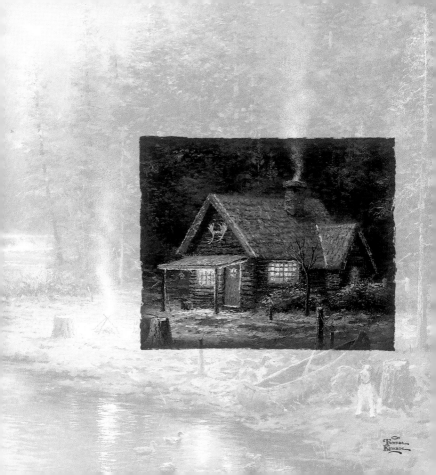

Thomas Kinkade

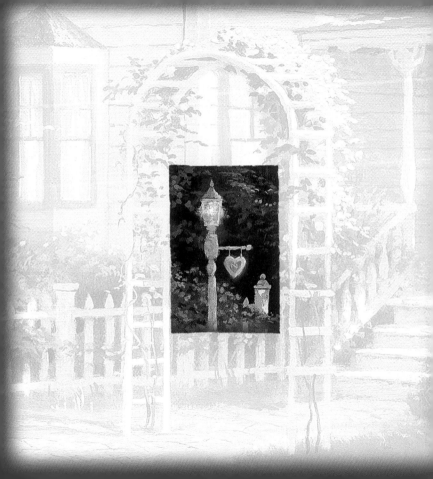

*Y*ou belong to
your COUNTRY *as*
you belong to your
own MOTHER.

EDWARD EVERETT HALE

*T*here is not
freedom on earth
or in any star for
those who deny
freedom to others.

ELBERT HUBBARD

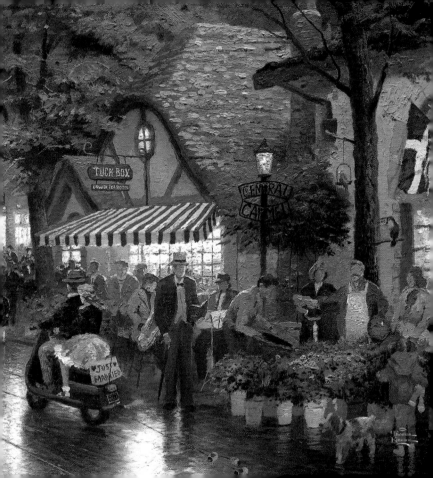

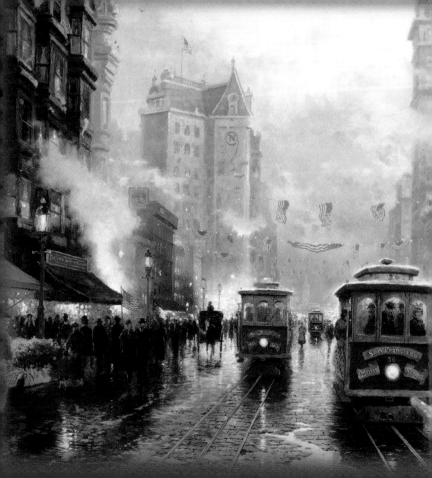

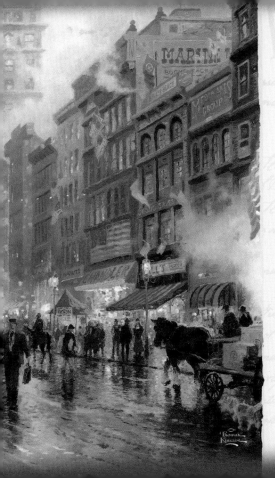

*P*eace and
friendship with
all mankind is
our wisest policy,
and I wish we
may be permitted
to pursue it.

THOMAS JEFFERSON

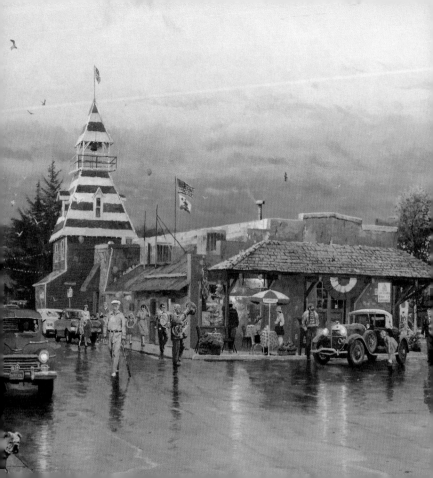

*L*et our object be our country, our whole country, and nothing but our country.

DANIEL WEBSTER

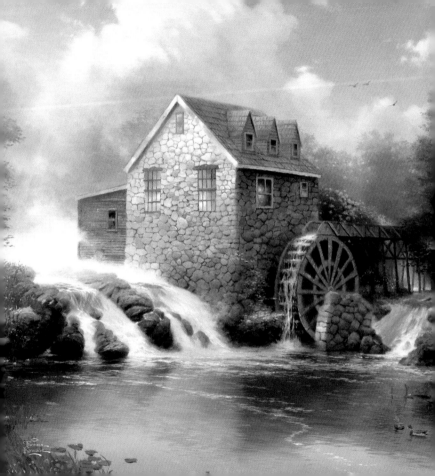

*W*hat we need
are critical lovers of
America—patriots who
express their faith in
their country by working
to improve it.

HUBERT H. HUMPHREY

It is the LOVE of
country that has
lighted and that
keeps glowing
the holy fire
of PATRIOTISM.

J. HORACE McFARLAND

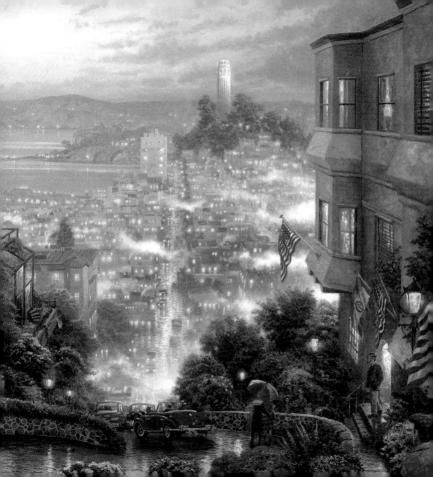

I venture to suggest that patriotism is not a short and frenzied outburst of emotion but the tranquil and steady dedication of a lifetime.

ADLAI STEVENSON

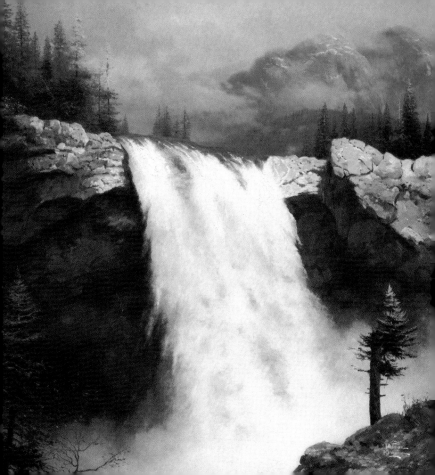

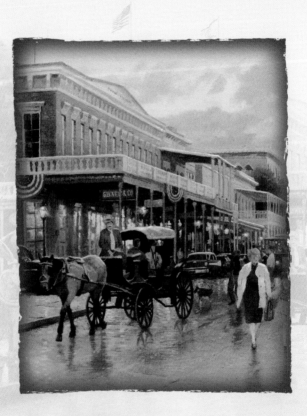

I shall know but one country.
The ends I aim at shall be
my country's, my God's and Truth's.

I WAS BORN AN AMERICAN;
I LIVE AN AMERICAN;
I SHALL DIE AN AMERICAN.

DANIEL WEBSTER

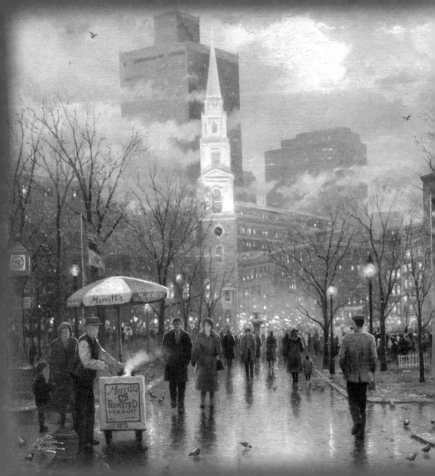

My AFFECTIONS

were first for

my own country,

and then, generally,

for all MANKIND.

THOMAS JEFFERSON

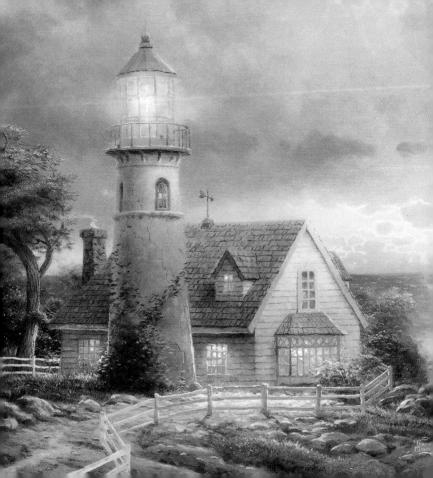

God bless America,

Land that I love.

Stand beside her, and guide her

Thru the night with a light from above.

From the mountains to the prairies,

To the oceans white with foam,

God bless America,

My home sweet home.

From the song "GOD BLESS AMERICA"
by IRVING BERLIN

AMERICA
is great because
America is GOOD.
And if America
ever ceases to be
good, America
will cease to
be GREAT.

ALEXIS DE TOCQUEVILLE

Thomas
Kinkade

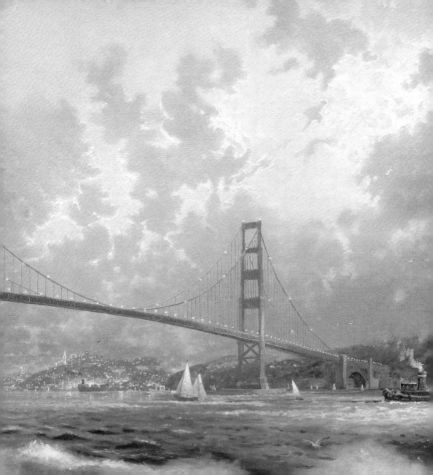

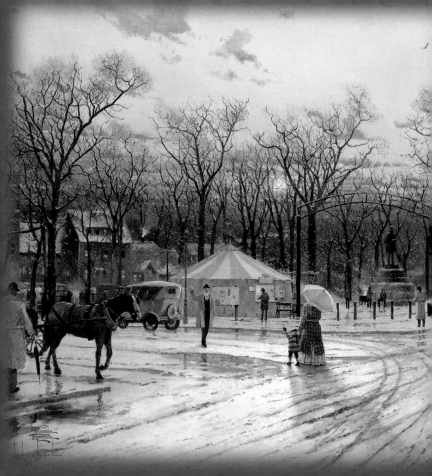

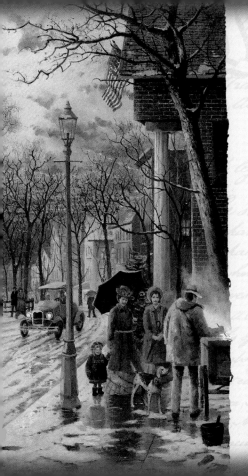

*T*hose who

deny FREEDOM

to others deserve

it not for

themselves.

And, under

a just GOD,

cannot long

retain it.

ABRAHAM LINCOLN

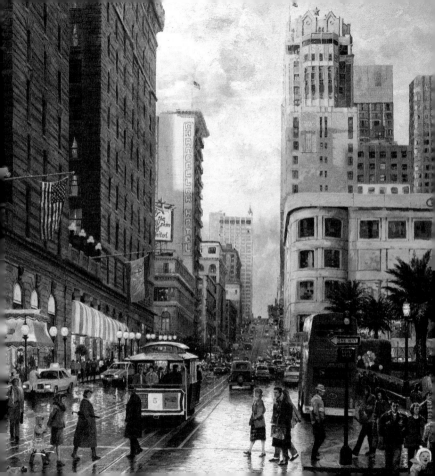

*L*oyalty must arise spontaneously from the hearts of people who love their country and respect their government.

HUGO L. BLACK

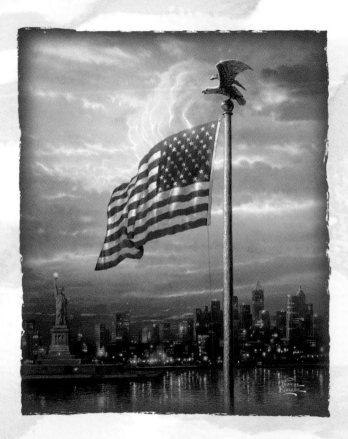

NATIONAL HONOR

is

NATIONAL PROPERTY

of the highest value.

JAMES MONROE

\mathcal{M}ay
the sun
in his course
visit no land
more free,
more happy,
more lovely,
than this our
own country!

DANIEL WEBSTER

Tis not in numbers
but in UNITY that our
great STRENGTH lies.

THOMAS PAINE

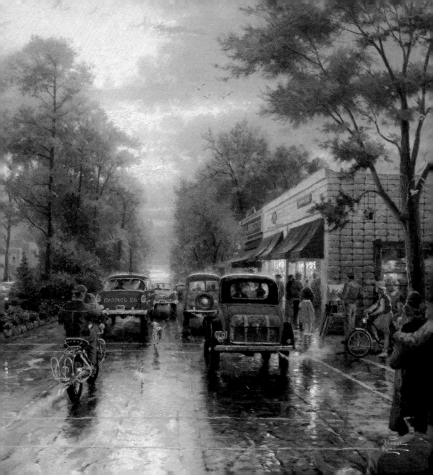

*T*he great and
admirable strength of
America consists in this:
that America is truly the
AMERICAN PEOPLE.

JACQUES MARITAIN

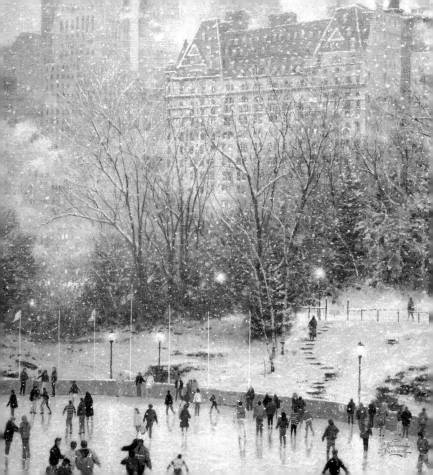

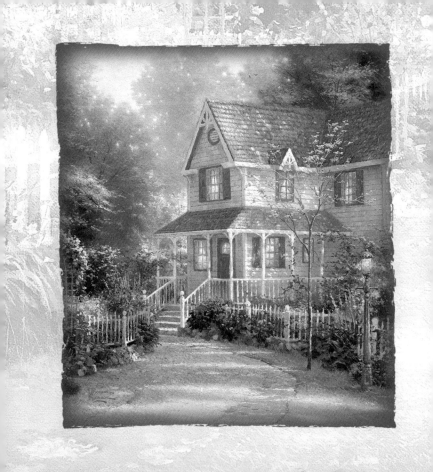

*W*here
LIBERTY
DWELLS,
there is my country.

BENJAMIN FRANKLIN

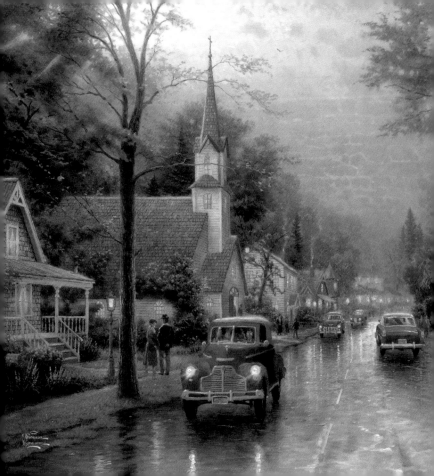

There is no power on earth equal to the power of free men and women united in the bonds of human brotherhood.

WALTER P. REUTHER

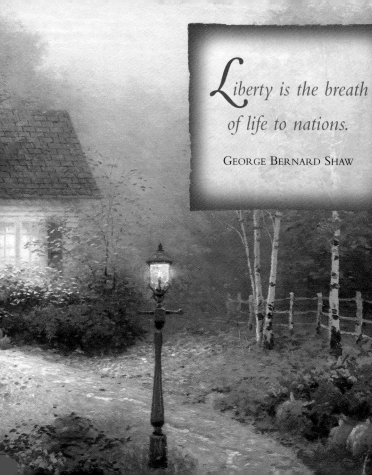

Liberty is the breath
of life to nations.

GEORGE BERNARD SHAW

Let every nation know,

whether it wishes us well or ill,

that we shall pay any price,

bear any burden, meet any hardship,

support any friend, oppose any foe,

to assure the survival and success of

LIBERTY.

JOHN F. KENNEDY

I HAVE A DREAM THAT ONE
DAY THIS NATION WILL RISE UP
AND LIVE OUT THE TRUE
MEANING OF ITS CREED:

*"We hold these truths to be
self-evident, that all men
are created equal."*

MARTIN LUTHER KING JR.

*T*here is nothing
wrong with AMERICA *that*
cannot be cured with what
is right in AMERICA.

WILLIAM J. CLINTON

A man's feet must be planted in his country, but his eyes should survey the world.

GEORGE SANTAYANA

*Breathes there
the man with
soul so dead,*

*Who never to
himself hath said,*

*This is my own,
my native land!*

SIR WALTER SCOTT

A man's country
is not a certain area of land,
of mountains, rivers,
and woods, but it is a
principle; and patriotism is
loyalty to that principle.

GEORGE WILLIAM CURTIS

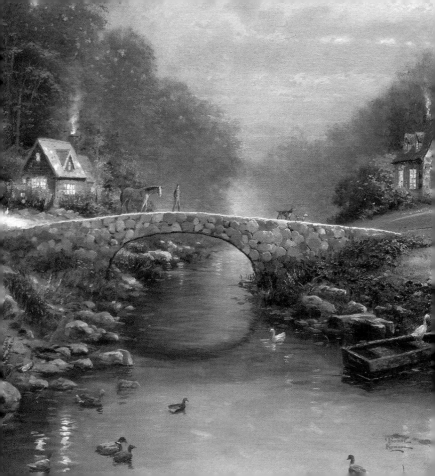

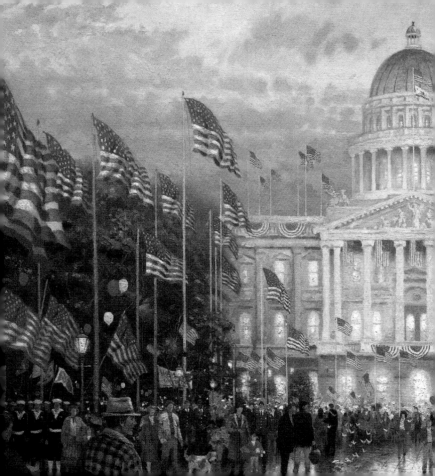

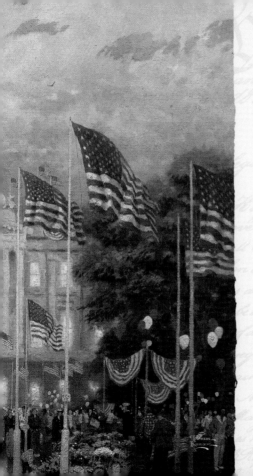

*I*NJUSTICE

anywhere is

a THREAT

to justice

everywhere.

MARTIN LUTHER KING JR.

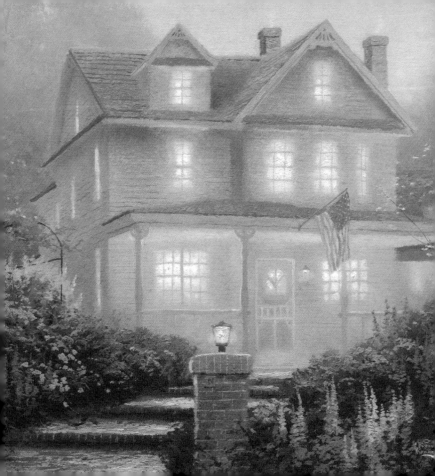

No nation can be destroyed while it possesses a good home life.

JOSIAH GILBERT HOLLAND

My God!

How little do my countrymen

know what precious blessings

they are in possession of,

and which no other people

on earth enjoy!

THOMAS JEFFERSON

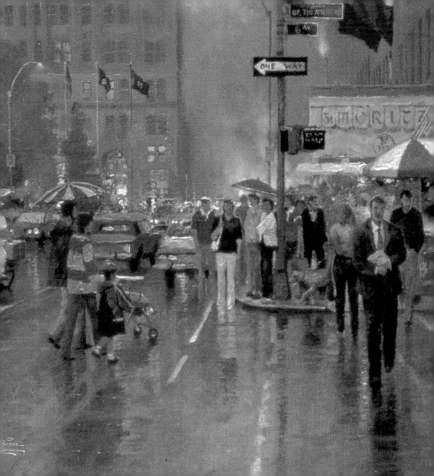

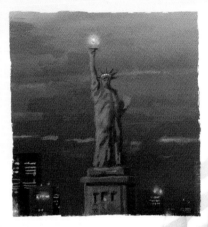

*O*ne man

with COURAGE

makes a

MAJORITY.

ANDREW JACKSON